Appalachia
The Southern Highlands

Appalachia
Landscapes
Series

MOUNTAIN TRAIL PRESS
Johnson City, Tennessee

Photography by
Jerry D. Greer

APPALACHIA
The Southern Highlands

Photography by

Jerry D. Greer

Book design and layout by Jerry Greer
Editing by Gordon McCray and Todd Caudle

Published by Mountain Trail Press
1818 Presswood Road
Johnson City, TN 37604
ISBN: 0-9676938-0-2
Printed in Korea

FRONT COVER: Autumn comes to Sam's Gap, Cherokee National Forest, Tennessee
BACK COVER (left to right): Evening light on an ancient rock formation, Shenandoah National Park, Virginia
Black-eyed susan along the Art Loeb Trail, Shining Rock Wilderness, North Carolina
Early morning fog along the New River, New River Gorge National River, West Virginia
TITLE PAGE: First light above the fog-filled valley, Roan Highlands, Tennessee / North Carolina
FACING PAGE :Tablerock view to Hawksbill Mountain, Pisgah National Forest, North Carolina

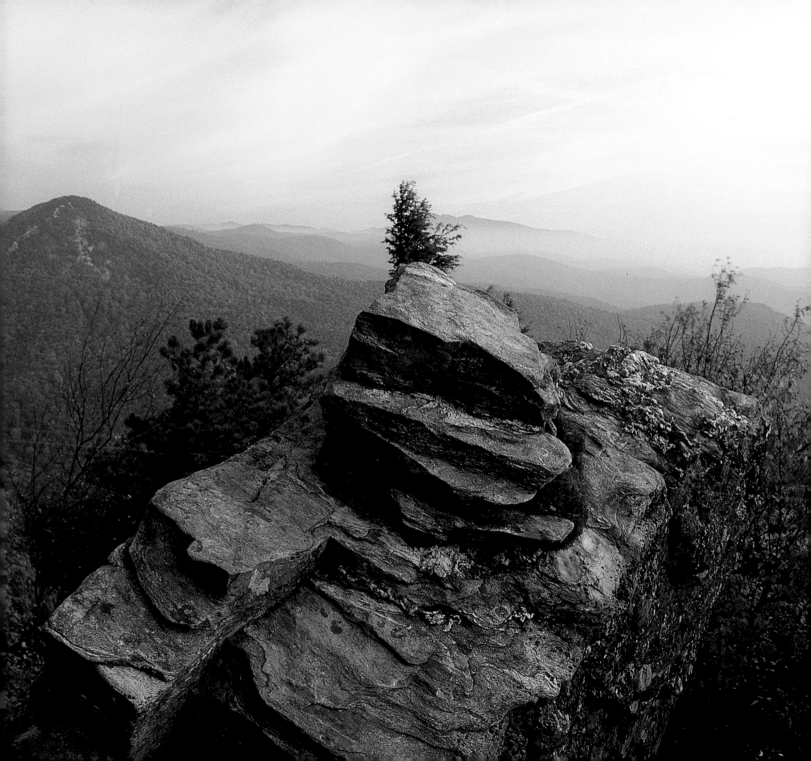

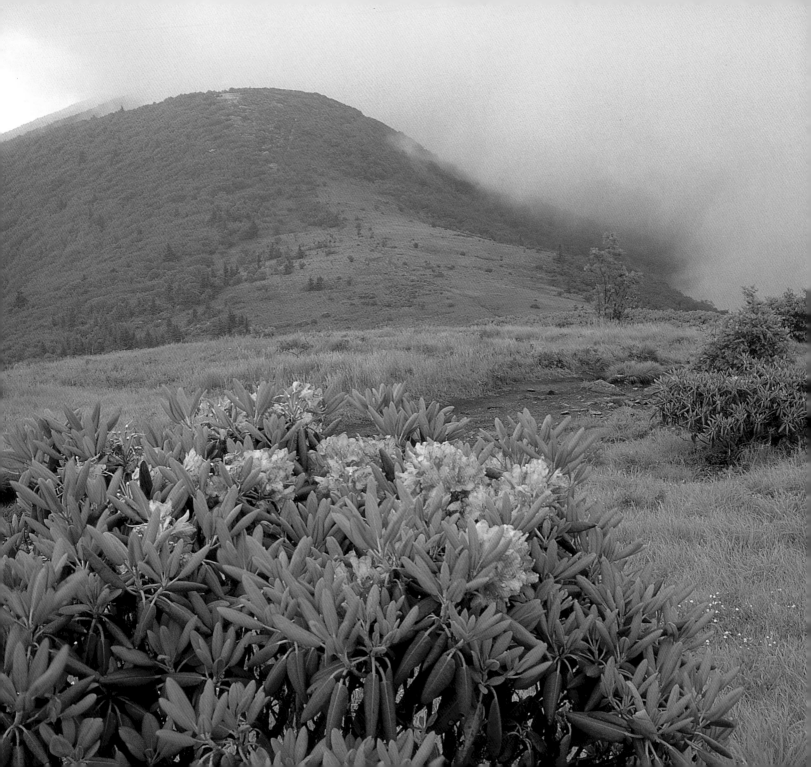

Introduction

It was sometime during the autumn of 1996 that my wife, Angela, and I made the difficult decision to leave Colorado. With the rugged peaks of the Rockies at our doorstep, we knew our years in this western playground had been a privilege. Still, the land of our birth beckoned. The time had come to return to the lush highlands of the southern Appalachians. Both Angela and I had spent the greater portion of our lives in those eastern mountains. Memories of a youth spent roaming the ridges and valleys of these old hills with rifle in hand and father in tow were still fresh. Later, I traded my rifle for a backpack and only then began to appreciate the splendor of the wilderness. But that was many years ago. Now I am intent upon not only living among those familiar Appalachians, but also capturing their beauty on film.

Contained within Appalachia are two national parks – Shenandoah National Park to the north and Great Smoky Mountain National Park in the south. Mount Mitchell, the highest point east of the Mississippi, stands nearby in western North Carolina. But perhaps the most distinctive feature of the highlands is the infamous series of balds that follows the spine of the Blue Ridge from northern Georgia to southwestern Virginia. Treeless ridge tops covered with indigenous grasses, catawba rhododendron, flame azalea and innumerable wild flowers, highland balds are cloaked in evocative Native American myth and legend. Open vistas stretch to distant mountains, often in full 360-degree panoramas. Stacked mountains tumble to the horizon at sunset while mountain tops rise like sentinels from the sea of fog that fills the valleys at sunrise. Crystal clear cascading streams teem with native fish, dense hardwood stands sustain flora and fauna too numerous to mention. Appalachia truly is a wondrous place.

But the southern Appalachians haven't always been a place of reflection and contemplation. Heavily logged in the early part of this century, virtually all old growth timber was lost to the axe and saw. Only within the last 50 years have the ecosystems of Appalachia rebounded. Yet another threat looms as human population growth places the natural wonder of these mountains under increasing stress. We are loving the Appalachians to death. This trend must be arrested. The forests must be preserved for future generations. They belong to no one time...no one people...no one use. They are for all people of all time. Eventually, the vast stands of chestnut and tulip poplar will return to rival the giants of the Great West. But only if all people respect and protect this most precious of Earth's resources. As you experience the images contained in this volume, allow yourself to embrace the beauty that is Appalachia. But remember always that these photographs are only images captured on film. The one true, real Appalachia is far more fragile. If, as a people, we do not proactively pursue the protection of these lands, then images such as those contained herein will be all we have to recall the splendor that is Appalachia.

— Jerry D. Greer

Summer storm overtakes Jane Bald, Roan Highlands, Tennessee / North Carolina

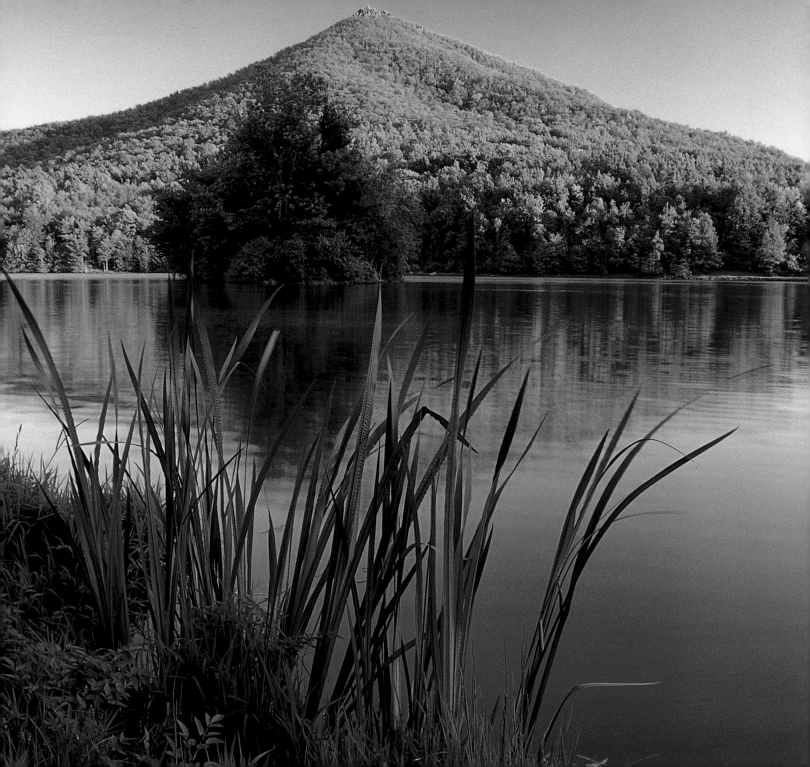

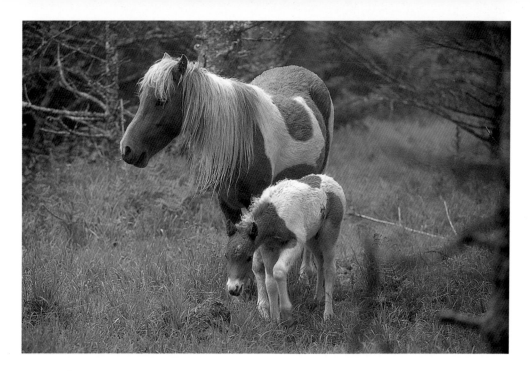

Feral ponies of the Virginia Highlands, Grayson Highlands State Park, Virginia

This book is dedicated to my wife, Angela Taylor Greer, for her love, companionship and support throughout my photographic pursuits; Both of our families, for their support while we are away capturing images; My mentors, Todd Caudle and Stephen Vaughan, for their sincere friendship and guidance in this glorious profession we call Nature Photography; Jerry Catron, a lifelong friend, for encouraging me (once more) to start shooting again. Without each of you this book would not have become a reality.

— Jerry D. Greer

Sharp Top, Peaks of Otter, Blue Ridge Parkway, Virginia

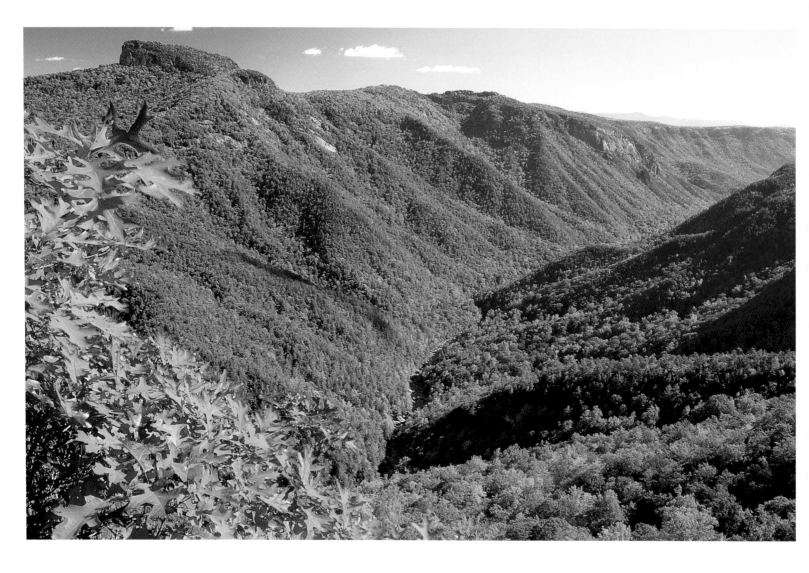

Oak and Tablerock Mountain overlook the Linville Gorge, Linville Gorge Wilderness, North Carolina

The golden grasses of fall come to the Highlands, Roan Highlands, Tennessee / North Carolina

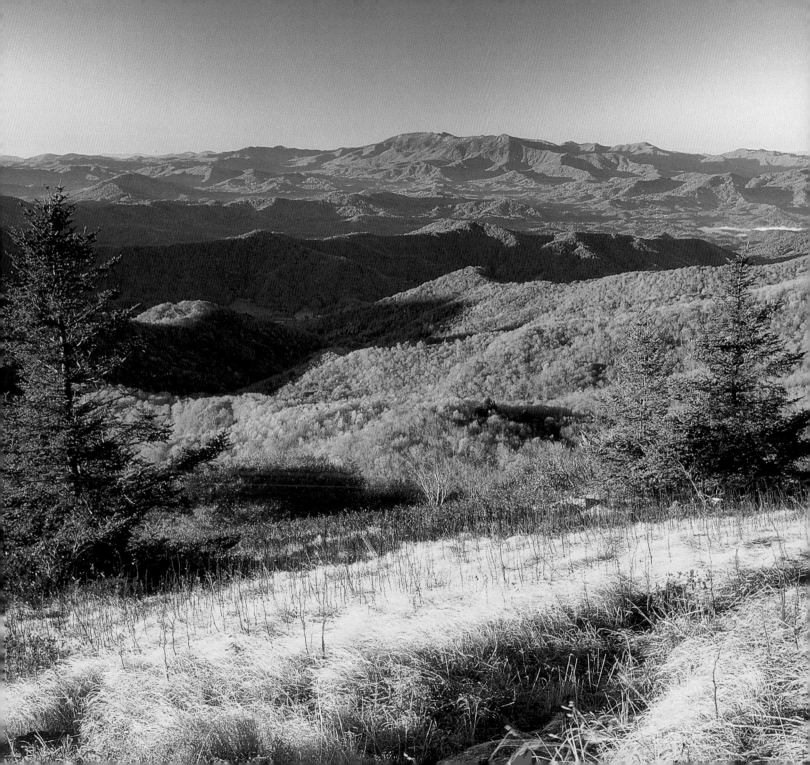

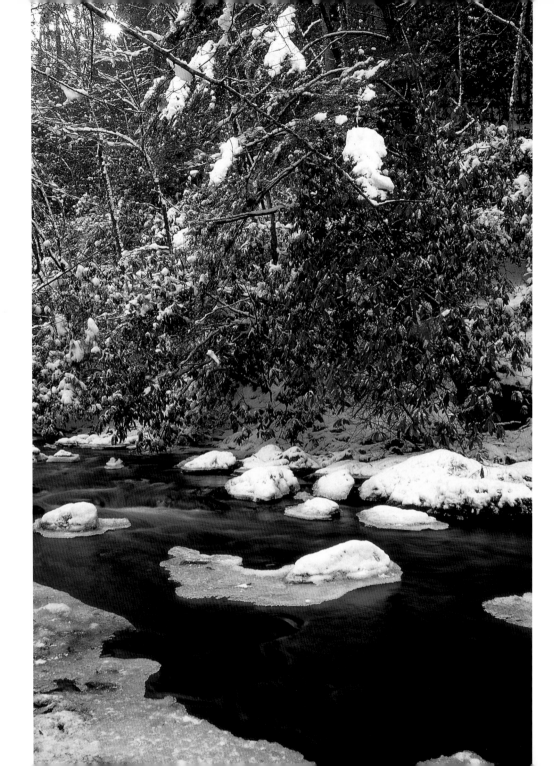

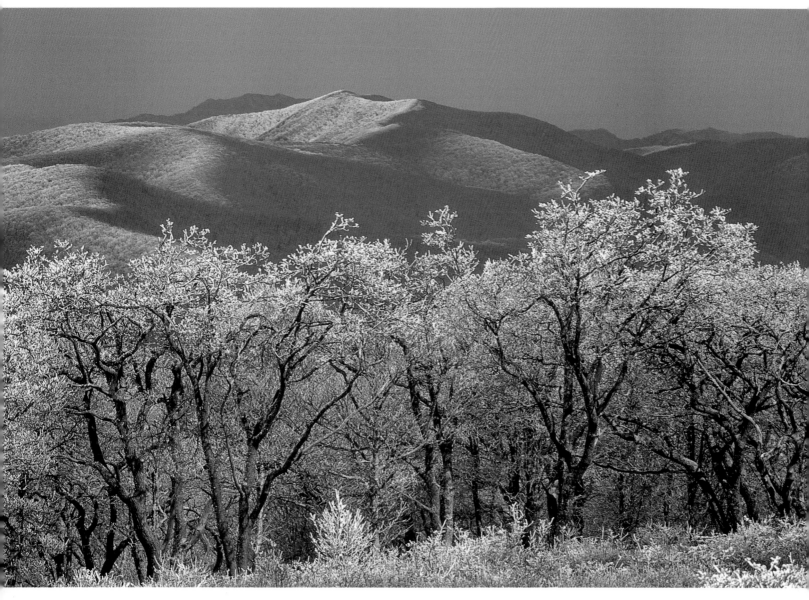

Icy vista of Thunderhead Mountain, Great Smoky Mountain National Park, Tennessee / North Carolina

Winter's grip along Paint Creek, Cherokee National Forest, Tennessee

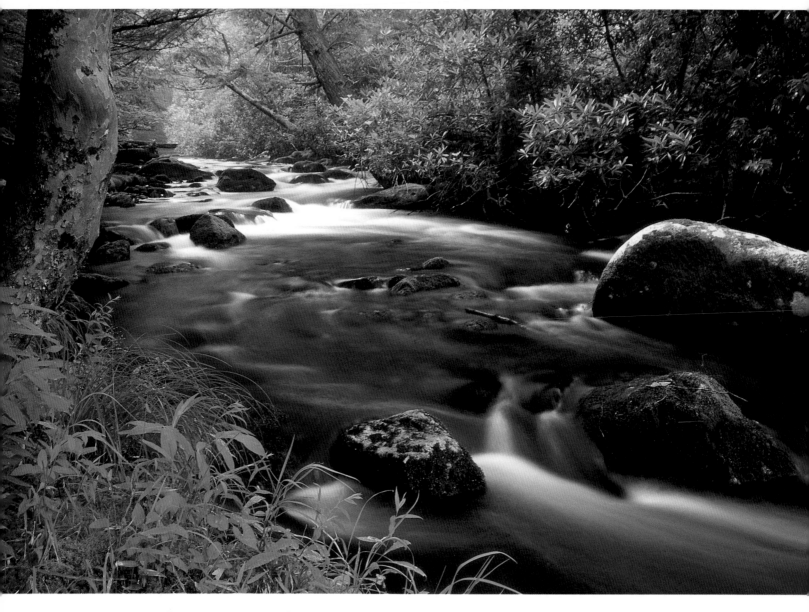

Sycamore along Hazel Creek, Great Smoky Mountain National Park, North Carolina / Tennessee

Signs of autumn come to the New River, New River Gorge National River, West Virginia

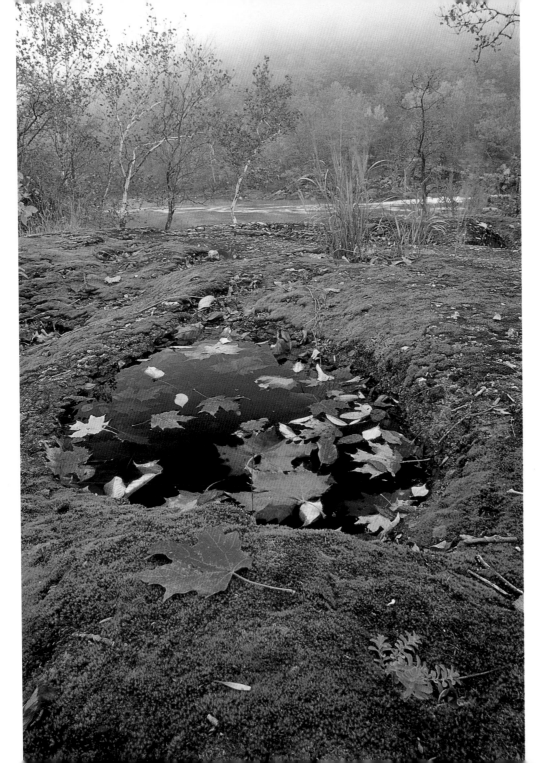

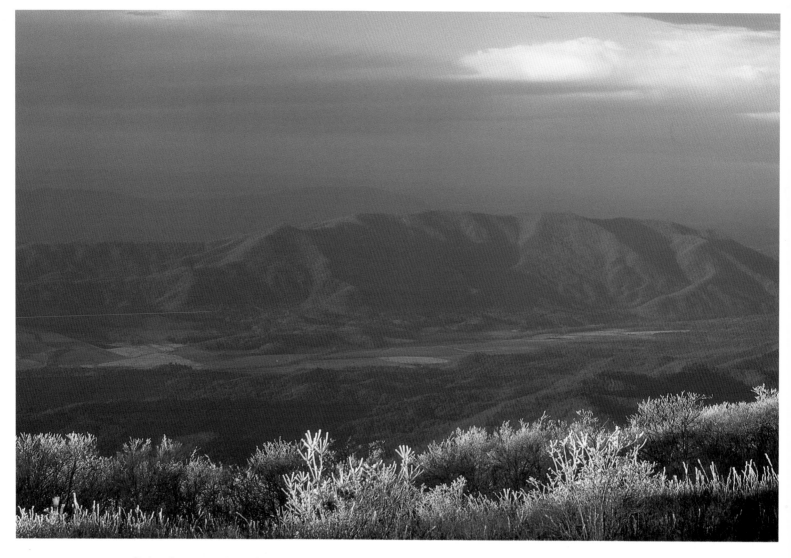

Cades Cove view from Gregory Bald, Great Smoky Mountain National Park, Tennessee / North Carolina

Backpacker's view to Unaka Mountain, Unaka Mountain Wilderness, Tennessee

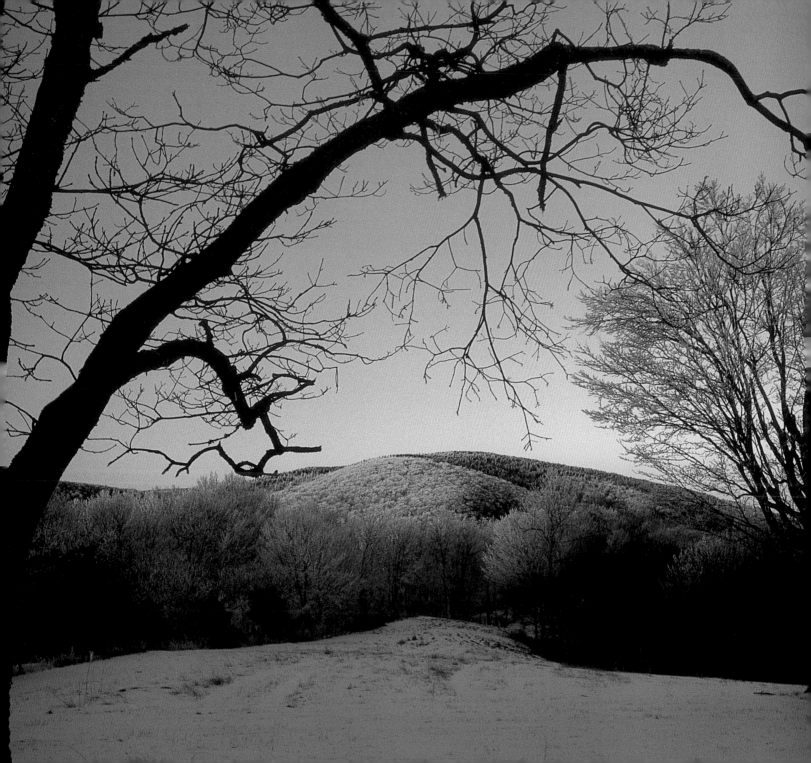

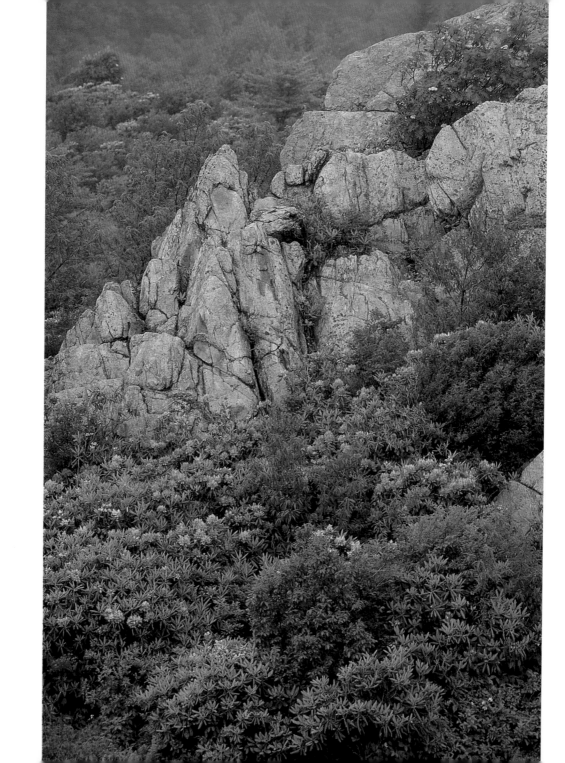

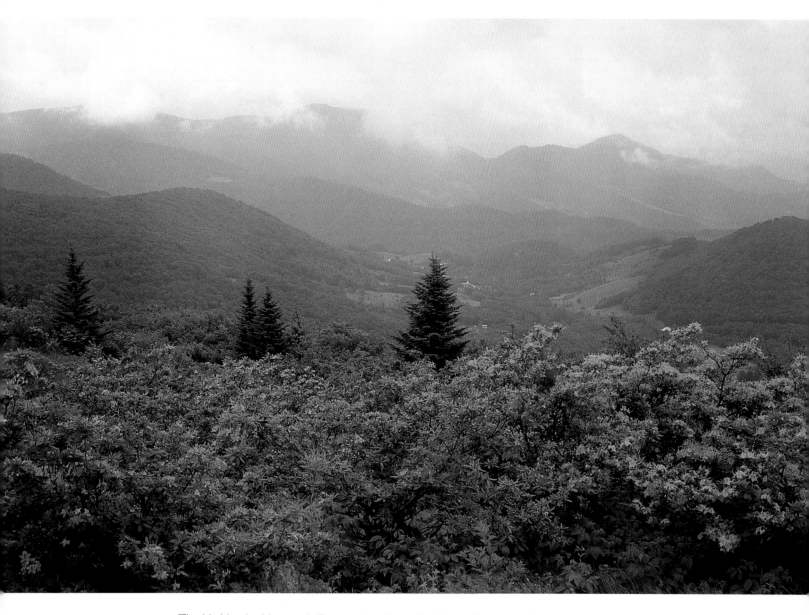

The Highlands ablaze with flame azalea, Roan Highlands, Tennessee / North Carolina

Rhododendron and ancient rock formation, Mount Rogers National Recreation Area, Virginia

Overleaf: Receding ridgelines and morning mist, Roan Highlands, North Carolina / Tennessee

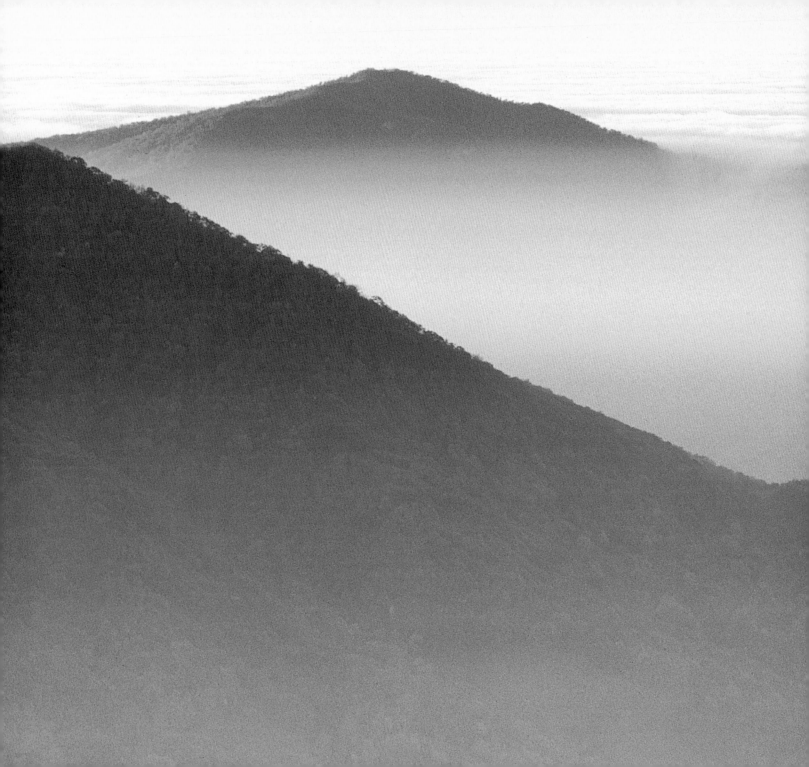

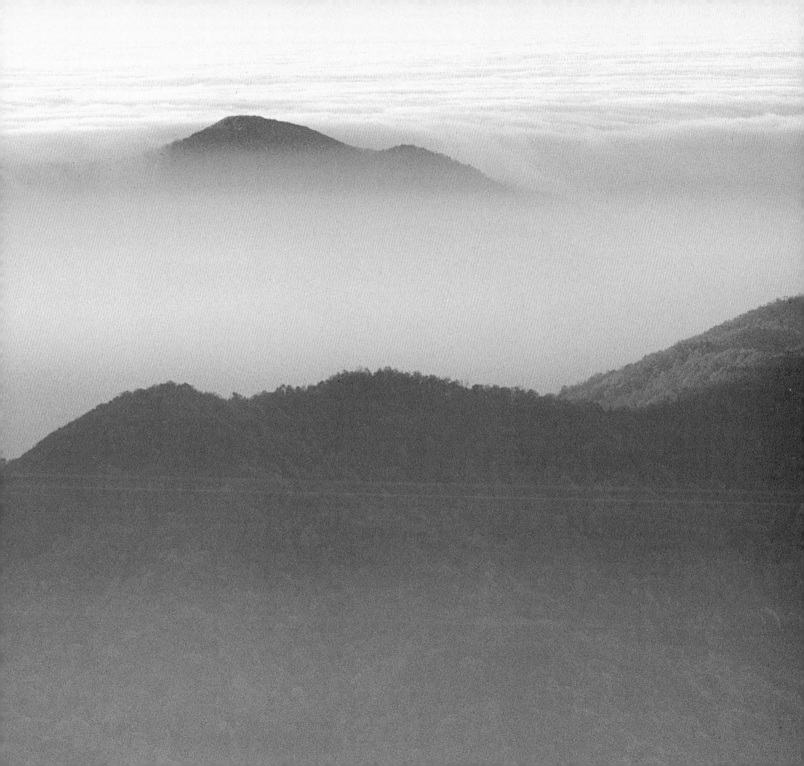

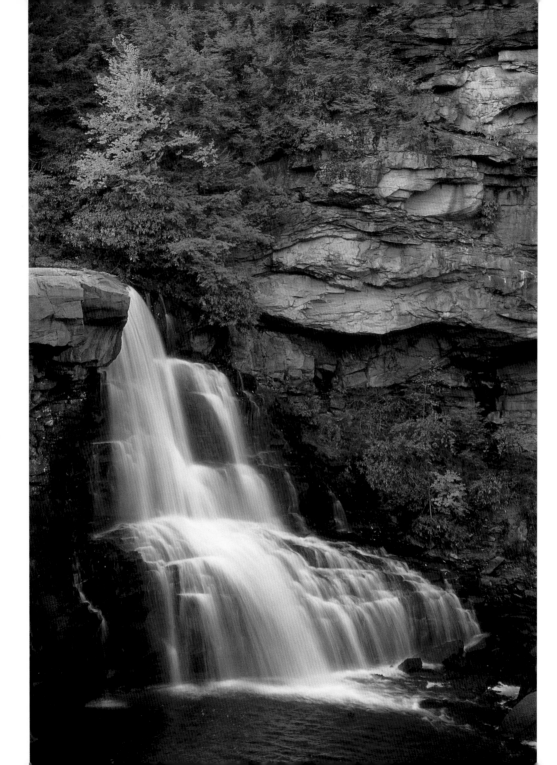

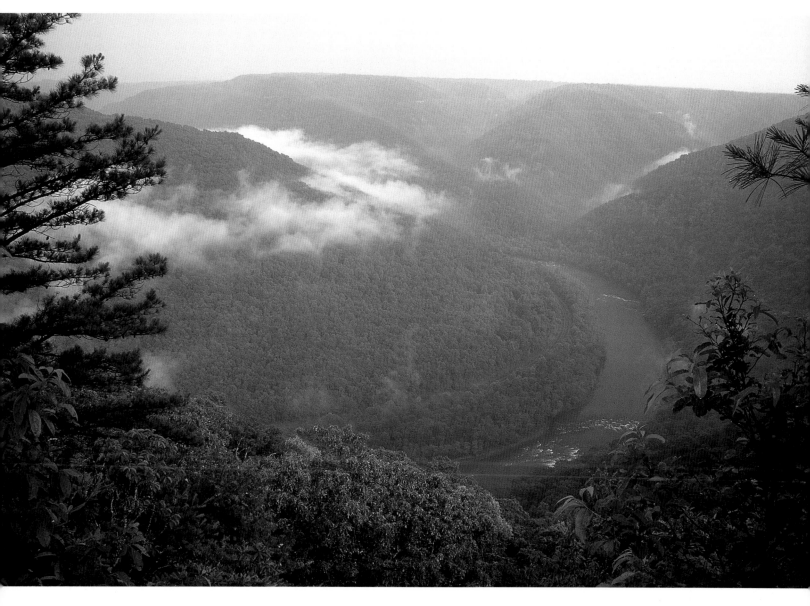

A summer thunderstorm retreats from the New River Gorge, New River Gorge National River, West Virginia

A touch of autumn comes to Blackwater Falls, Blackwater Falls State Park, West Virginia

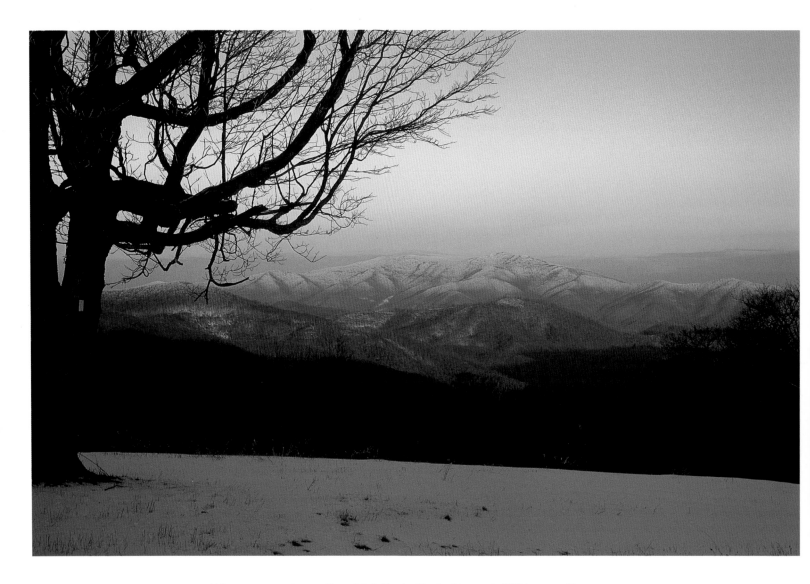

Winter sunset vista to Roan High Knob, Unaka Mountain Wilderness, Tennessee

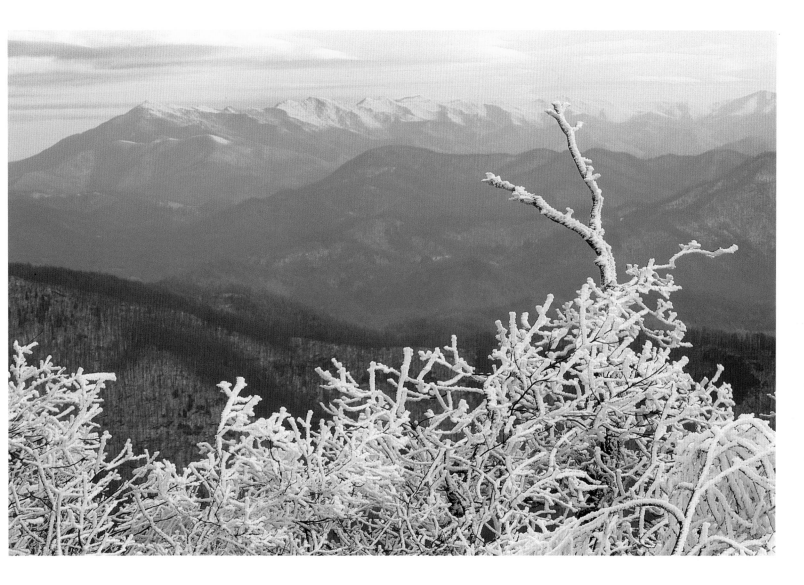

Looking to Mount Mitchell and the Black Mountains of North Carolina, Unaka Mountain Wilderness, Tennessee

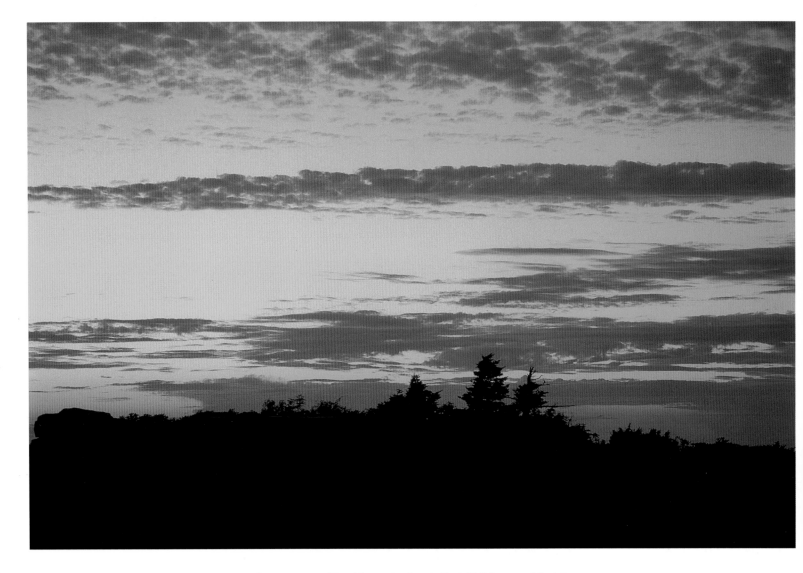

Sunset across Pine Mountain, Lewis Fork Wilderness, Virginia

Summer sunset from the Blackrocks, Shenandoah National Park, Virginia

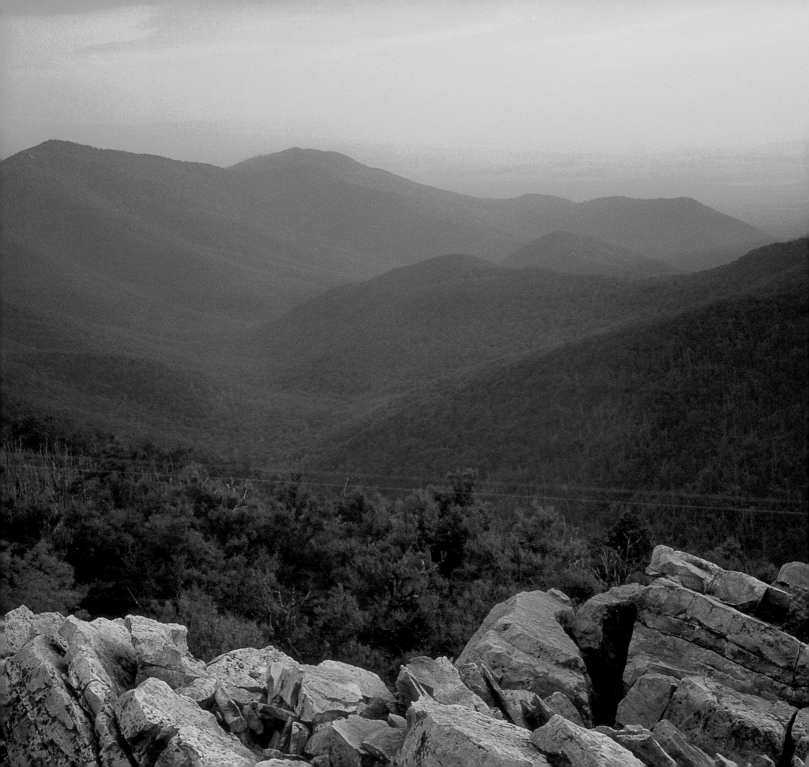

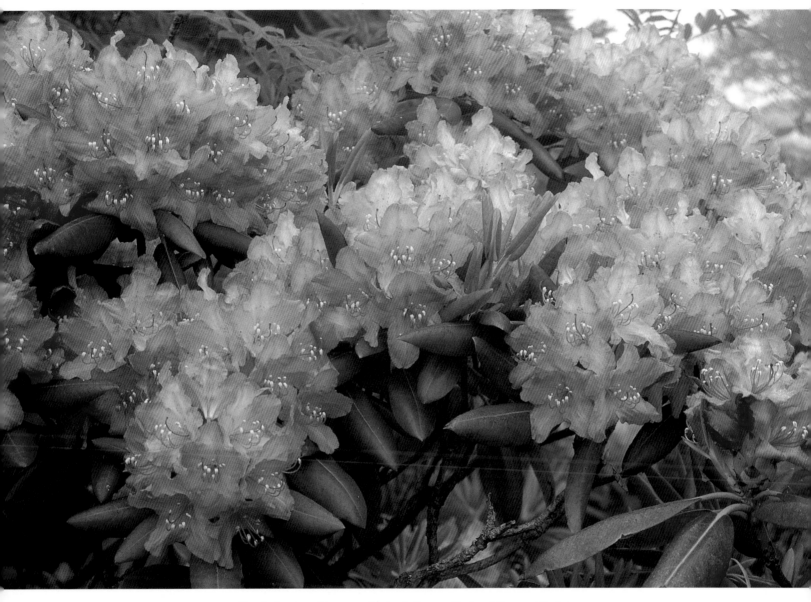

Rhododendron blossoms in the Jefferson National Forest, Virginia

Wood-nettle along the Lewis Spring Falls Trail, Shenandoah National Park, Virginia

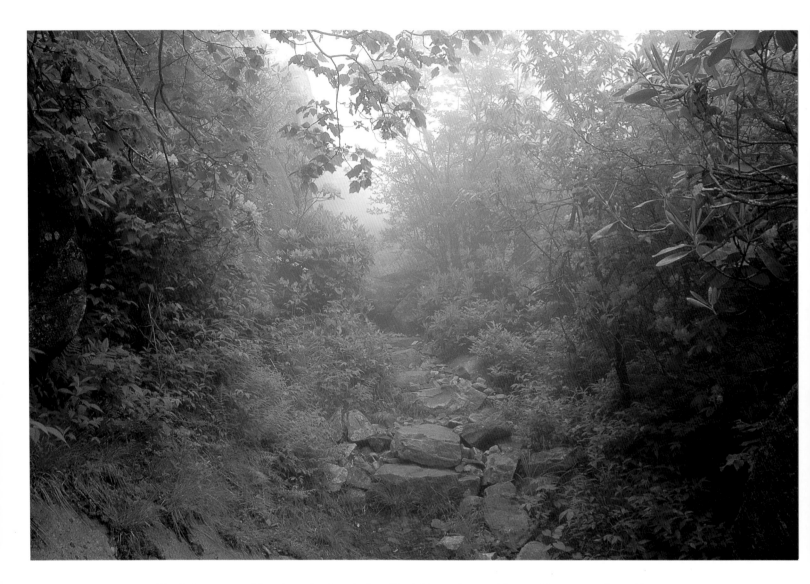

Rhododendron and fog along the Appalachian Trail, Mount Rogers National Recreation Area, Virginia

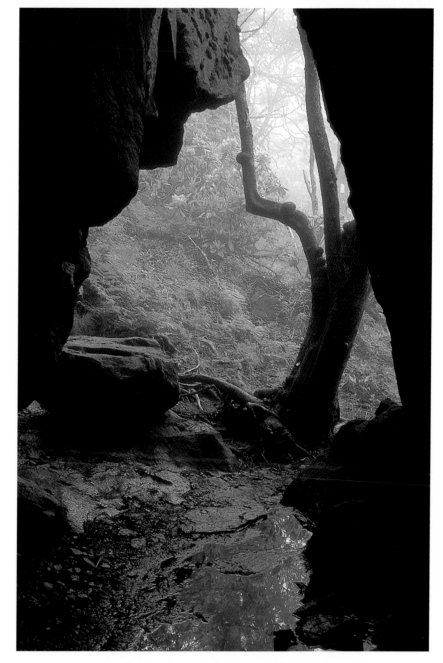

The Fatman Squeeze Tunnel, Appalachian Trail,
Mount Rogers National Recreational Area, Virginia

Overleaf: Evening view from Blackrock Summit, Shenandoah National Park, Virginia

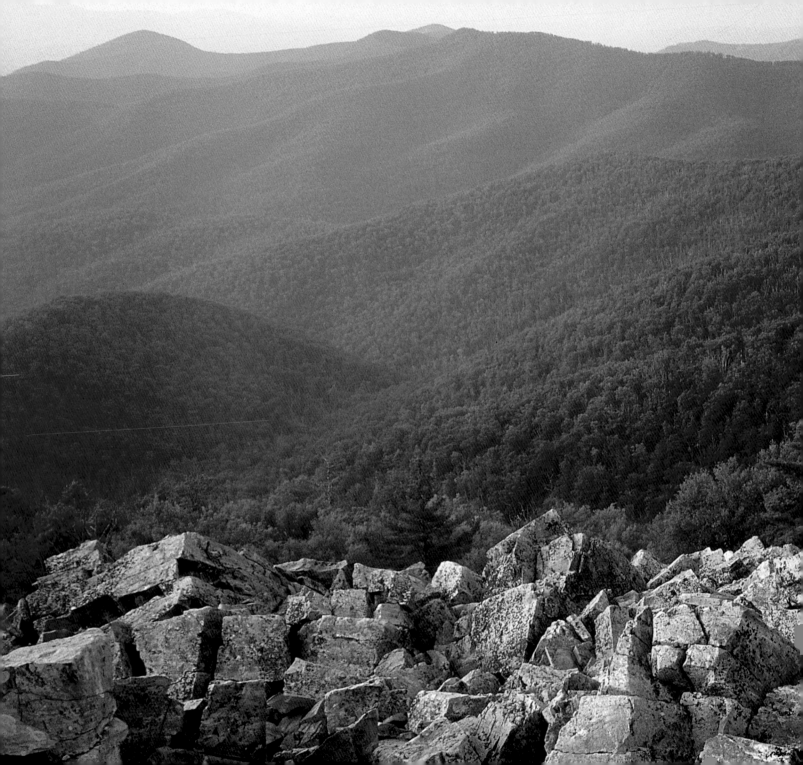

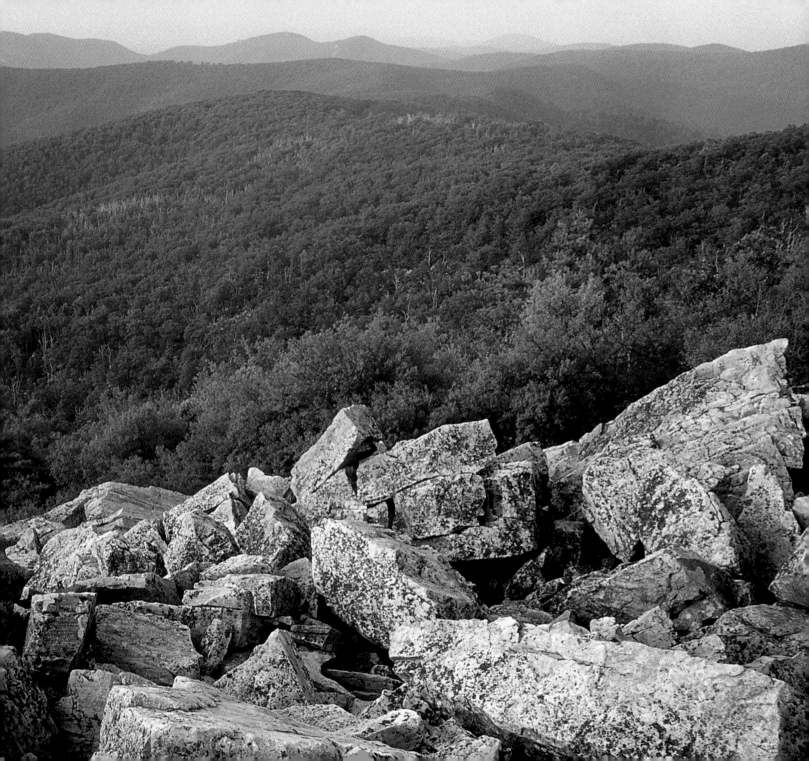

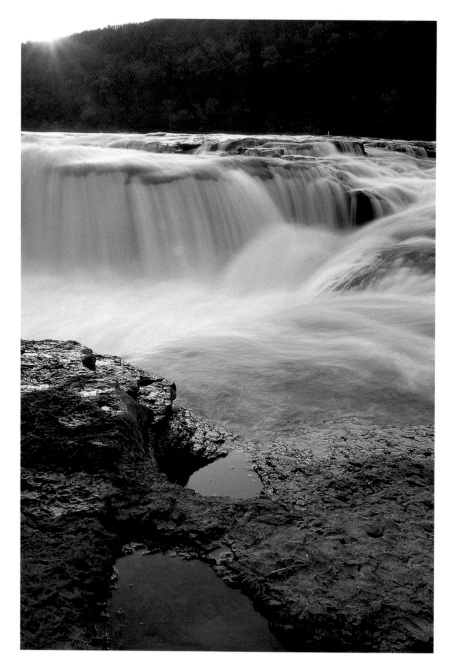

Spring awakens the New River,
New River Gorge National River, West Virginia

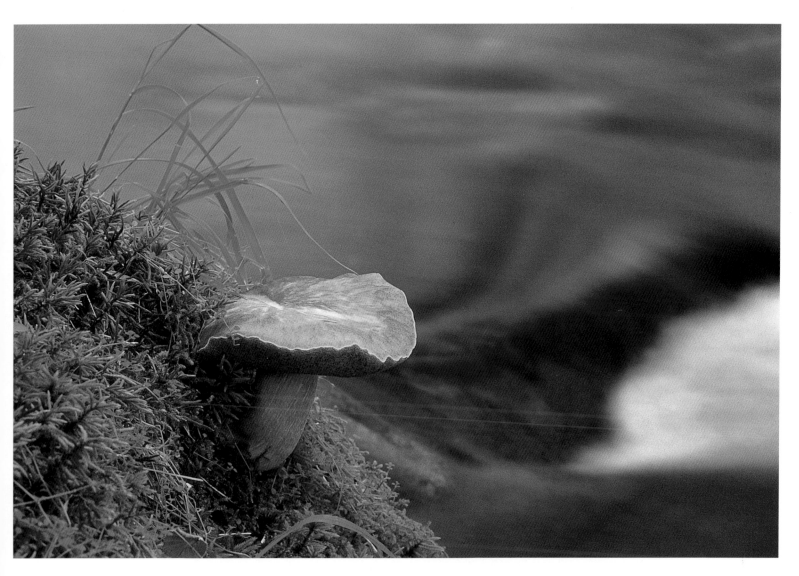

Mushroom and moss along Bone Valley Creek, Great Smoky Mountain National Park, North Carolina / Tennessee

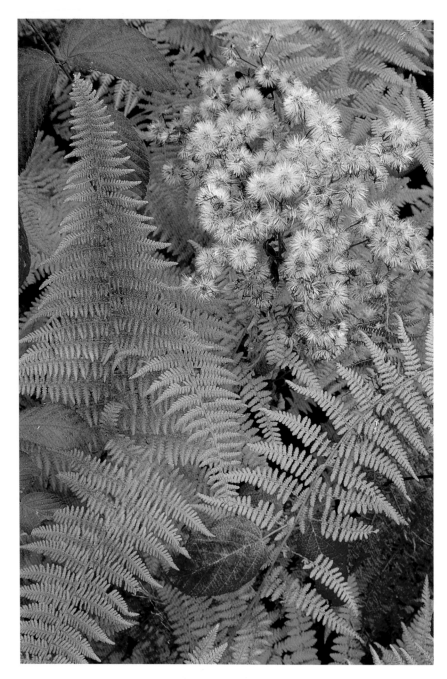

Autumn paints the forest foliage, Shenandoah National Park, Virginia

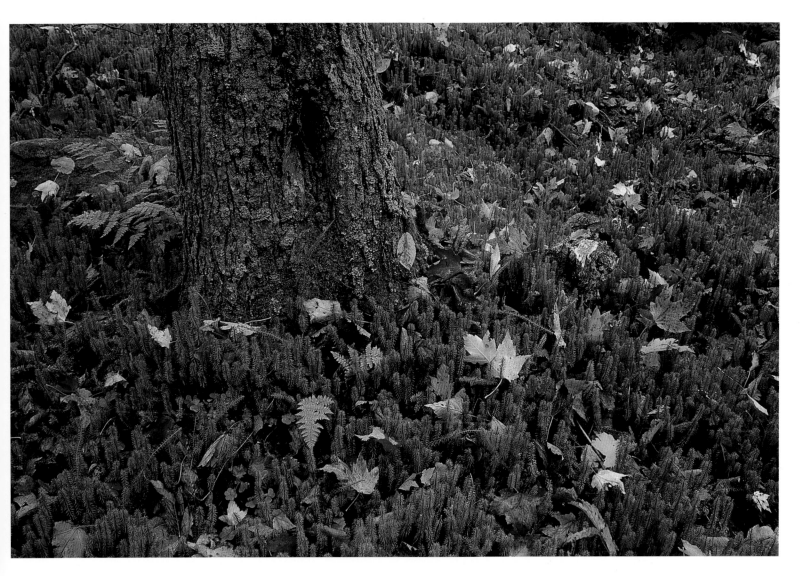

The early signs of autumn begin to cover the forest floor, Monongahela National Forest, West Virginia

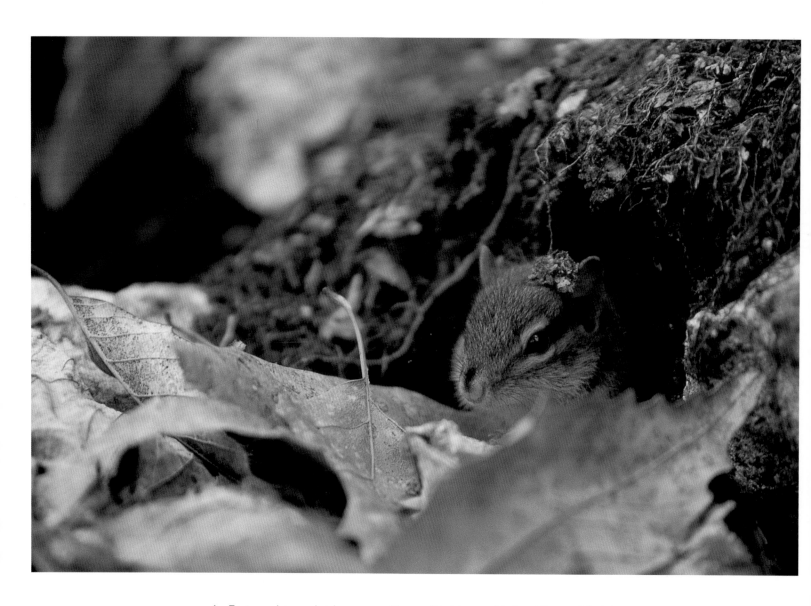

An Eastern chipmunk takes cover, George Washington National Forest, Virginia

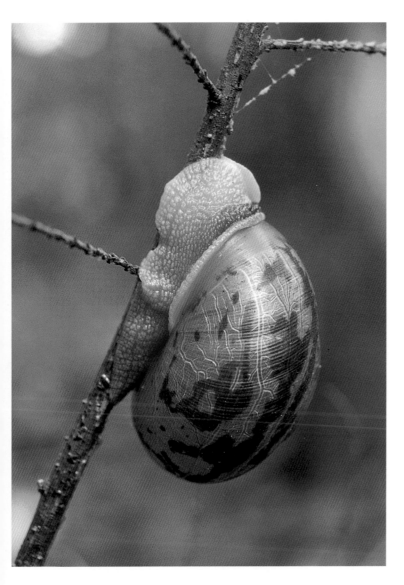

A snail clings to a twig along Big Creek,
Great Smoky Mountain National Park,
Tennessee / North Carolina

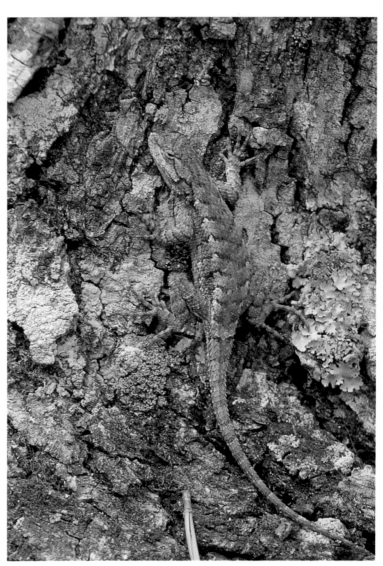

An Eastern fence lizard camouflaged on a tree,
Blue Ridge Parkway, North Carolina

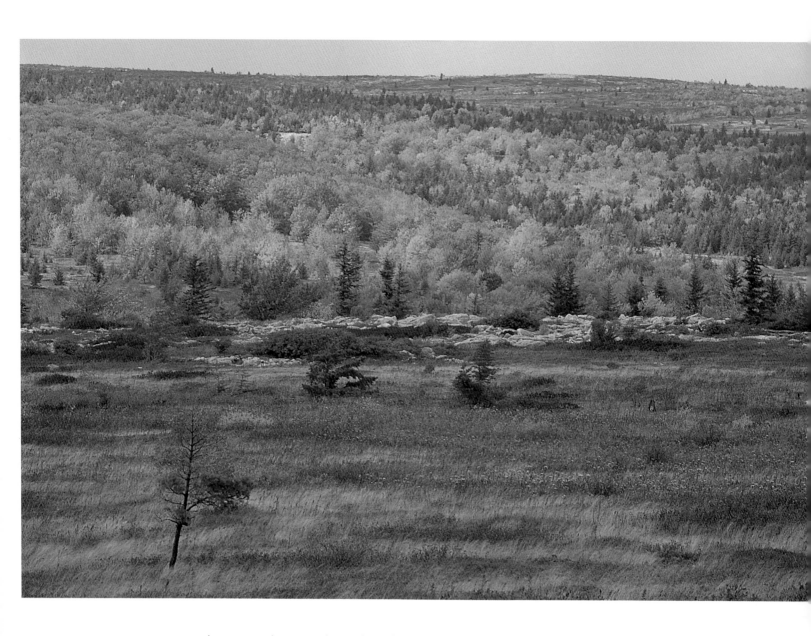

Autumn maples come alive with vivid color, Dolly Sods Scenic Area, West Virginia

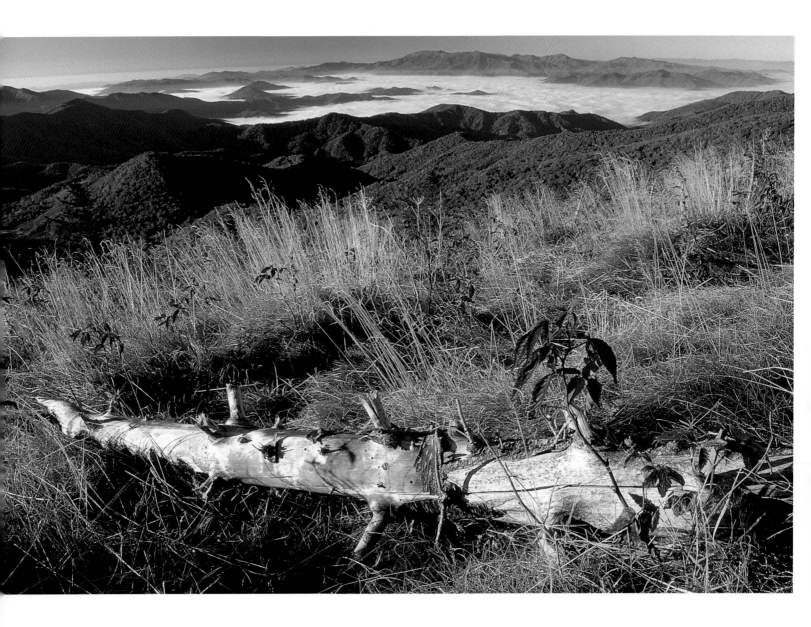

Old snag along the slopes of Round Bald, Roan Highlands, Tennessee / North Carolina

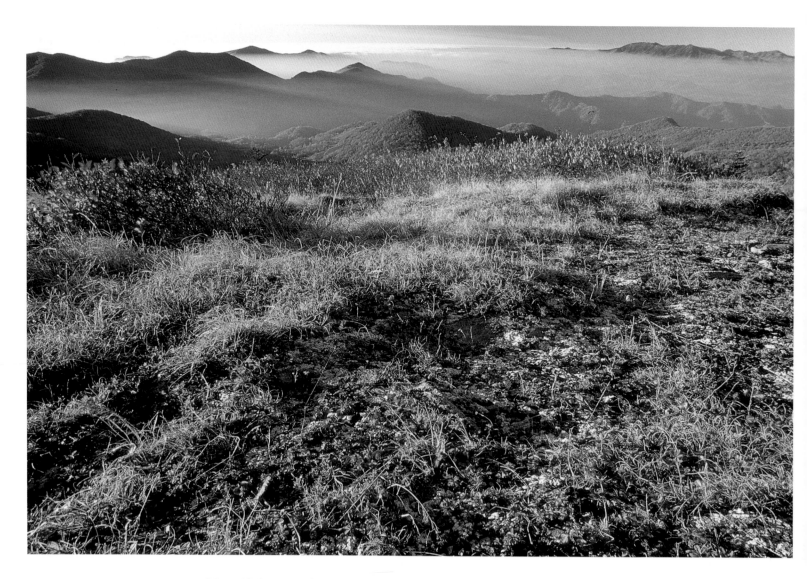

Magical light paints the autumn vista, Roan Highlands, North Carolina / Tennessee

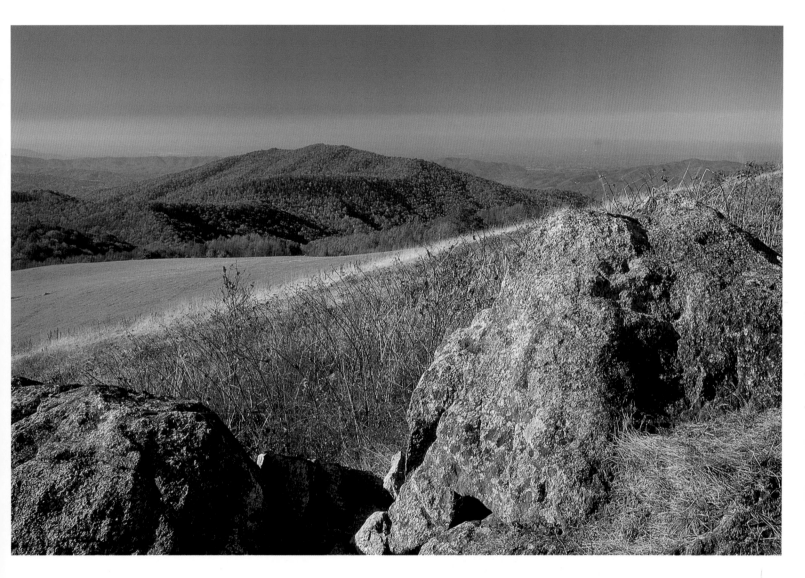

The hues of fall along the slopes of Max Patch Mountain, Pisgah National Forest, North Carolina

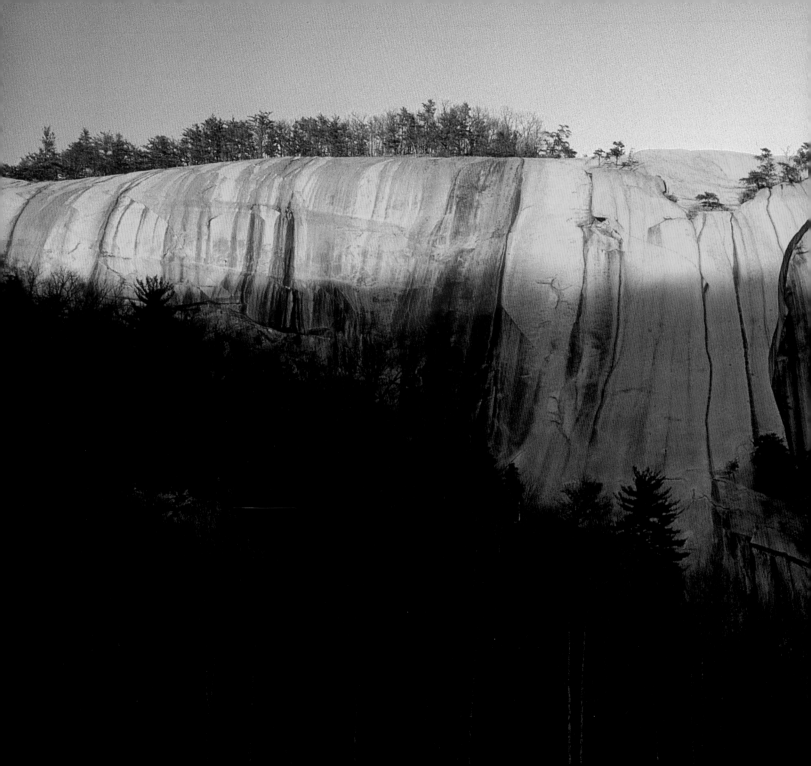

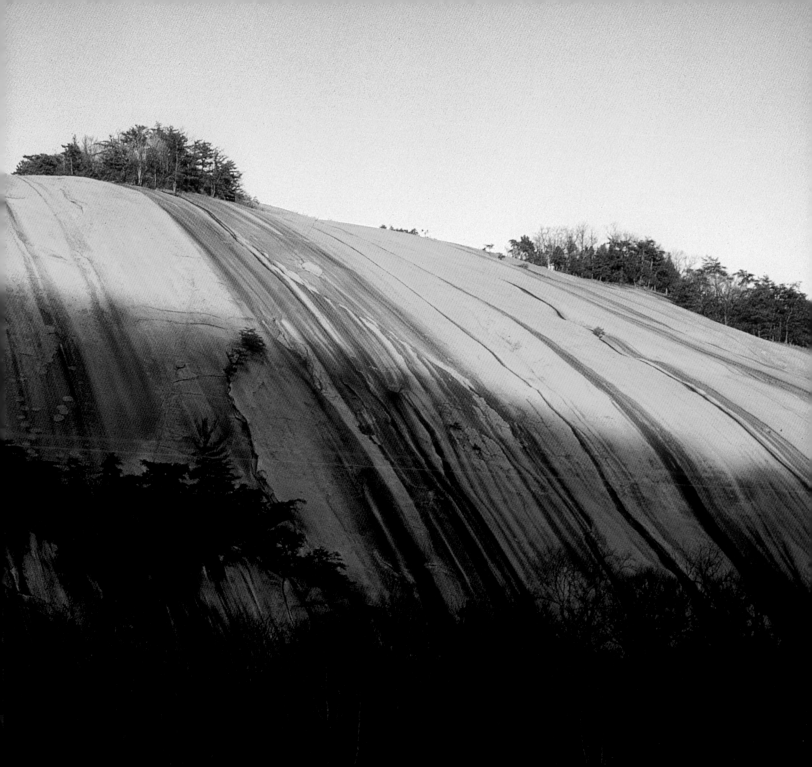

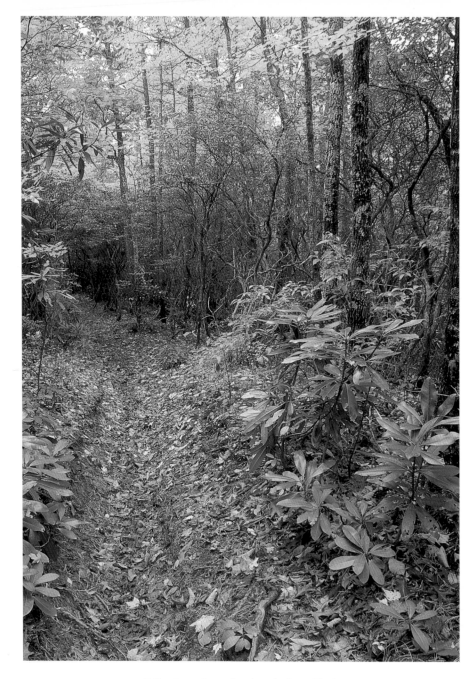

Fall colors along the Appalachian Trail,
Great Smoky Mountain National Park, Tennessee / North Carolina

Preceding page: Stone Mountain bathed in warm evening light, Stone Mountain State Park, North Carolina

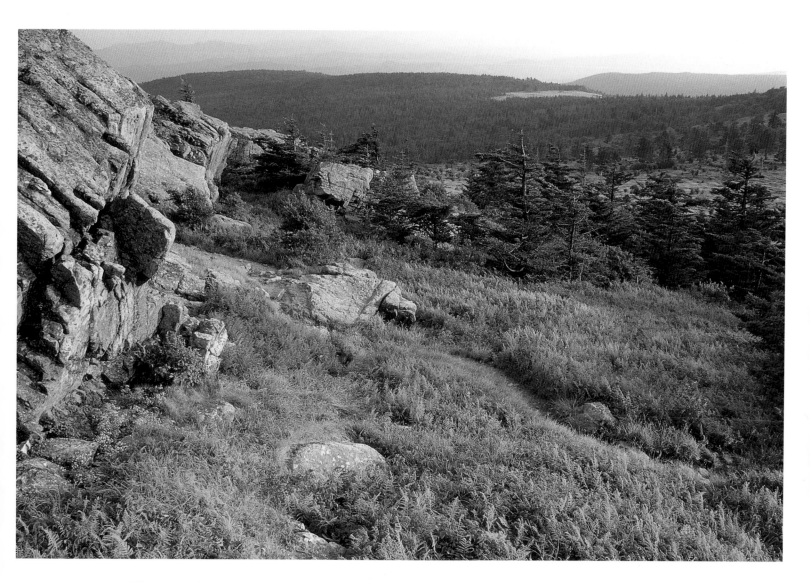

The Appalachian Trail meanders along Wilburn Ridge, Mount Rogers National Recreation Area, Virginia

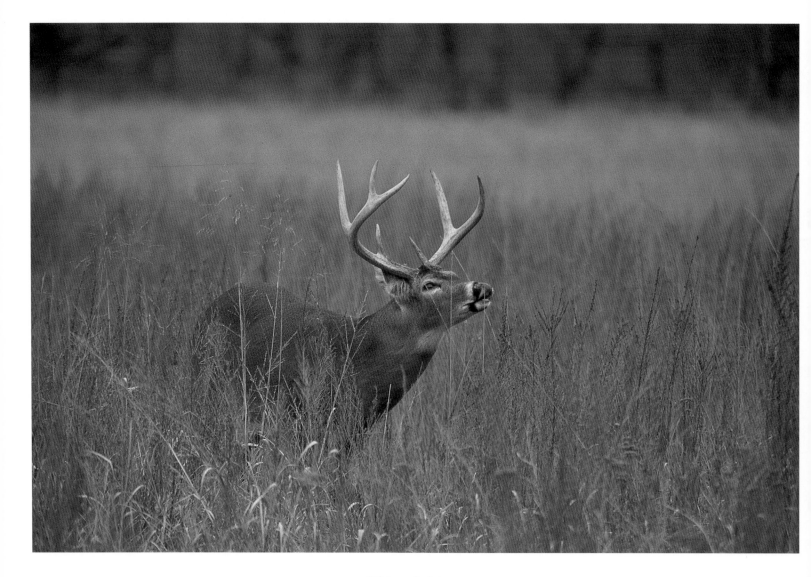

White-tailed deer

Wild animals of the Southern Appalachians

Black bear

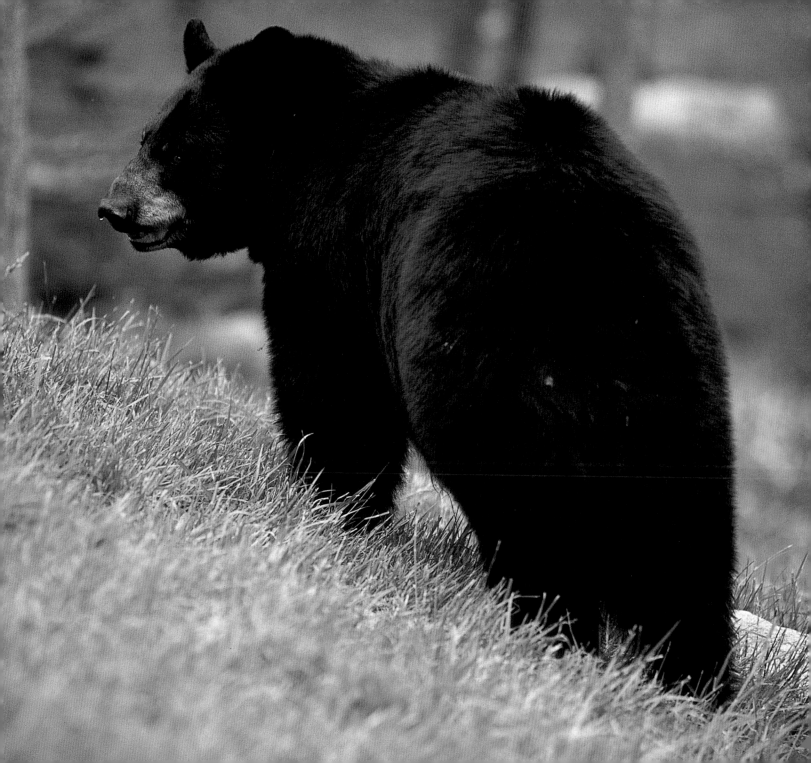

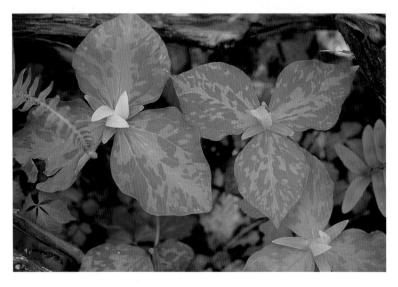
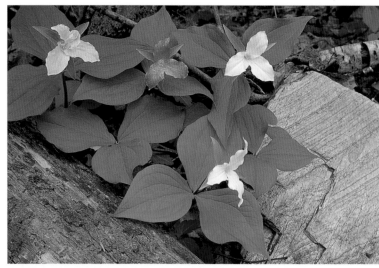
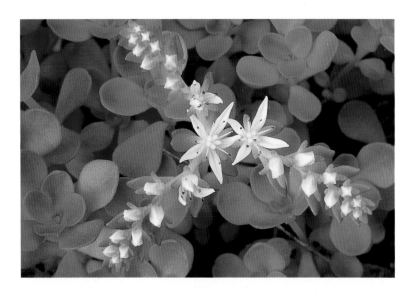
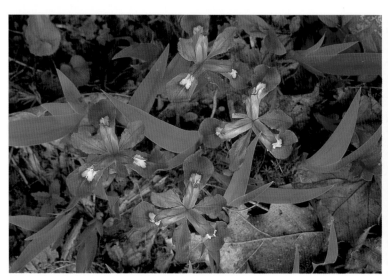

Wildflowers of the Southern Highlands

Wild stonecrop · White trillium

Yellow trillium · Crested dwarf iris

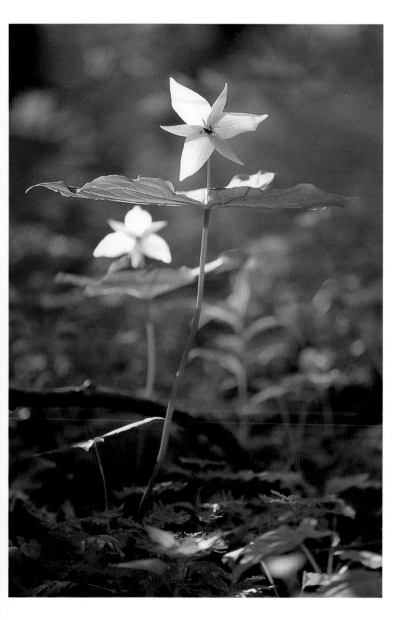

Sweet white trillium

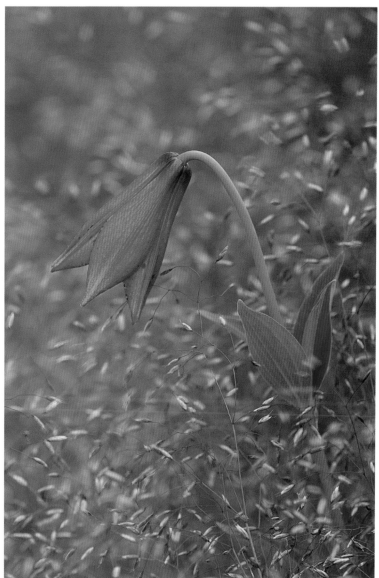

Gray's lily, a threatened plant species

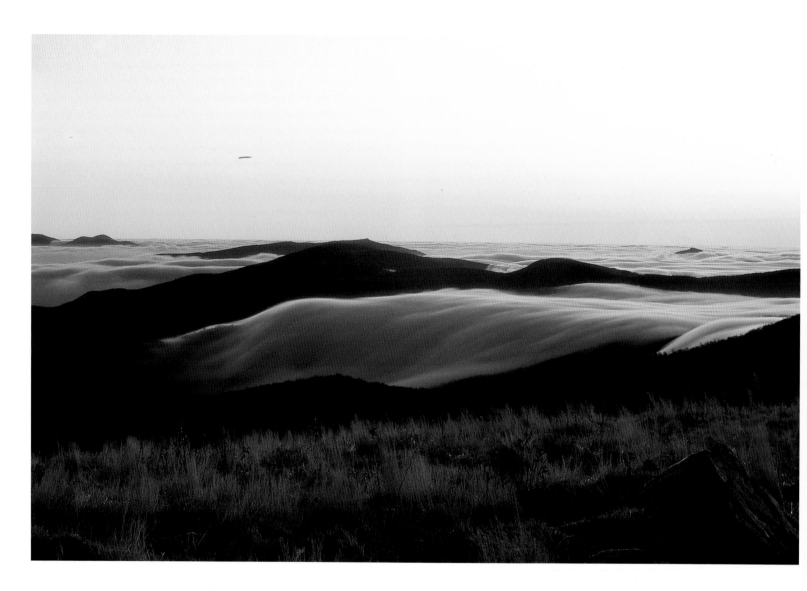

Storm clouds flow over the Highlands, Roan Highlands, North Carolina / Tennessee

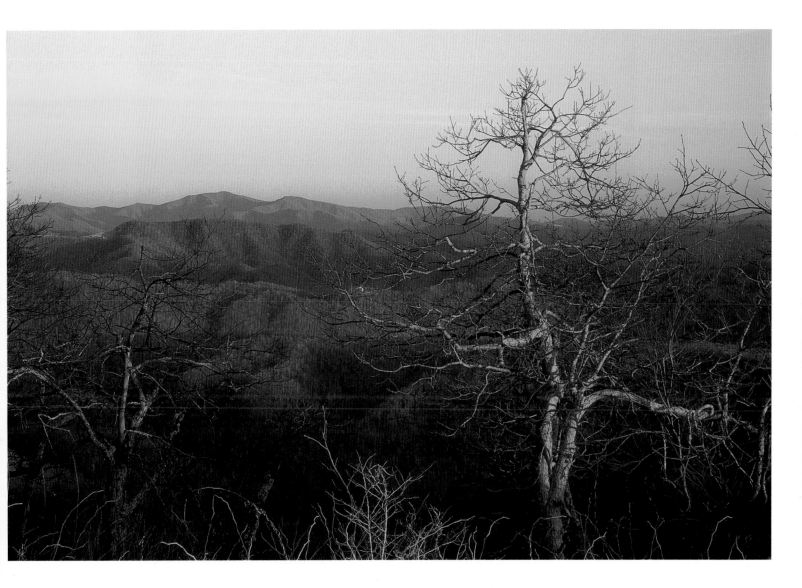

Evening light warms the autumn landscape, Unaka Mountain Wilderness, Tennessee

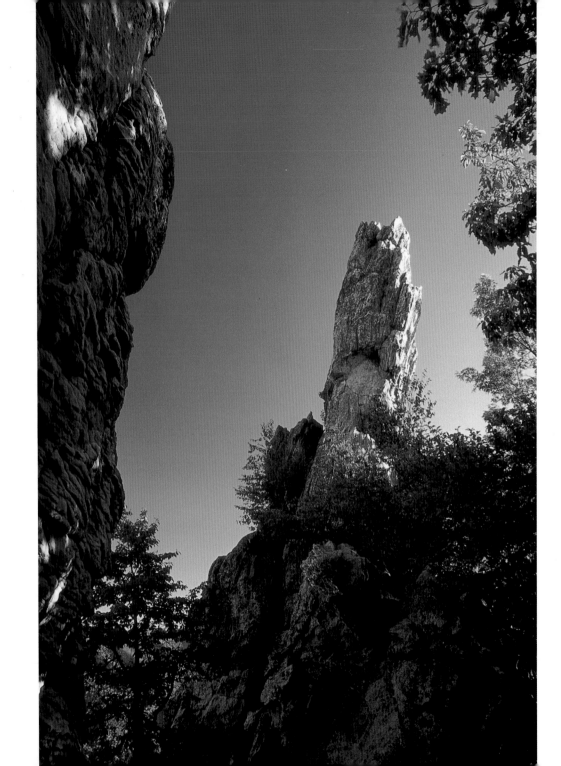

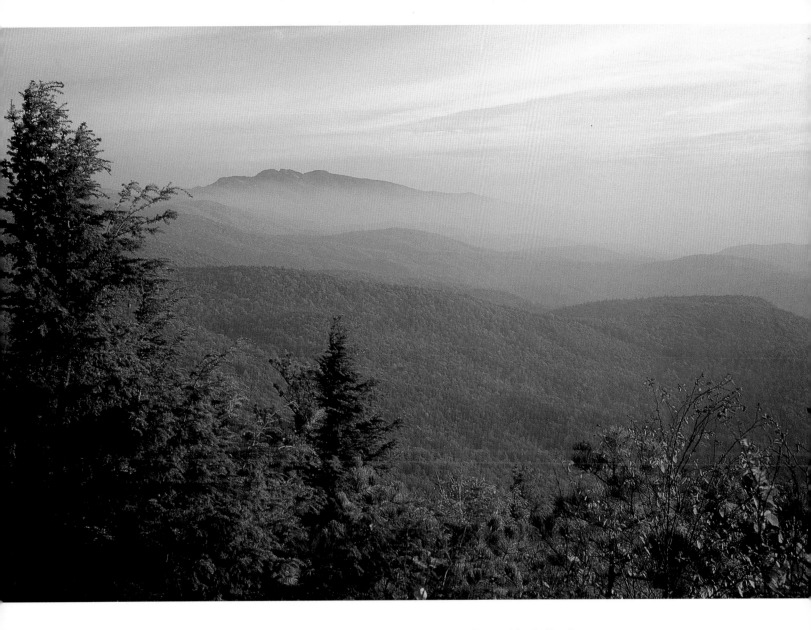

View to Grandfather Mountain, Pisgah National Forest, North Carolina

The sandstone spire of Dragon's Tooth, Jefferson National Forest, Virginia

Overleaf: Winter vista to Hump Mountain, Roan Highlands, Tennessee / North Carolina

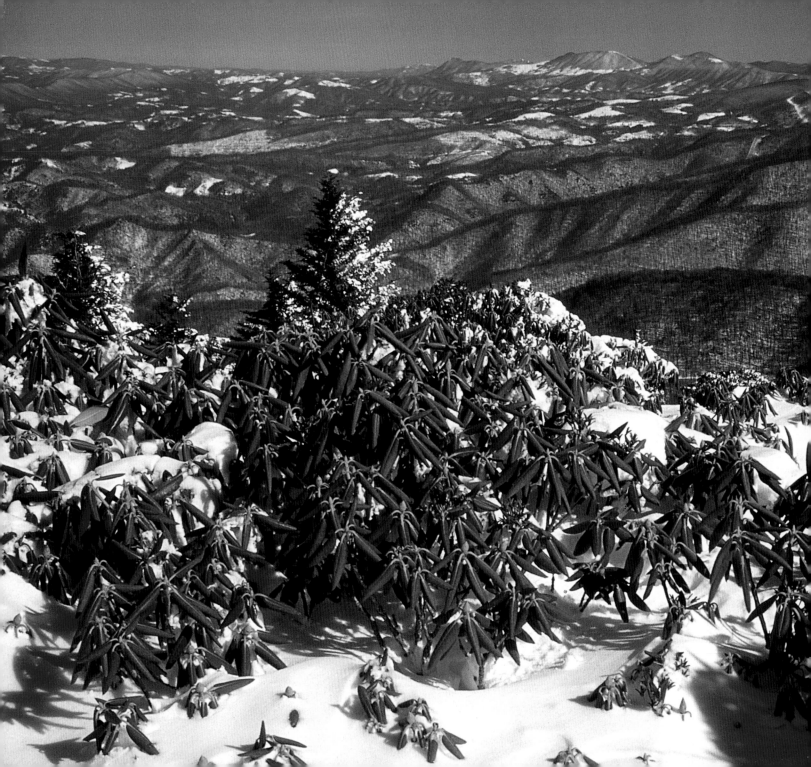

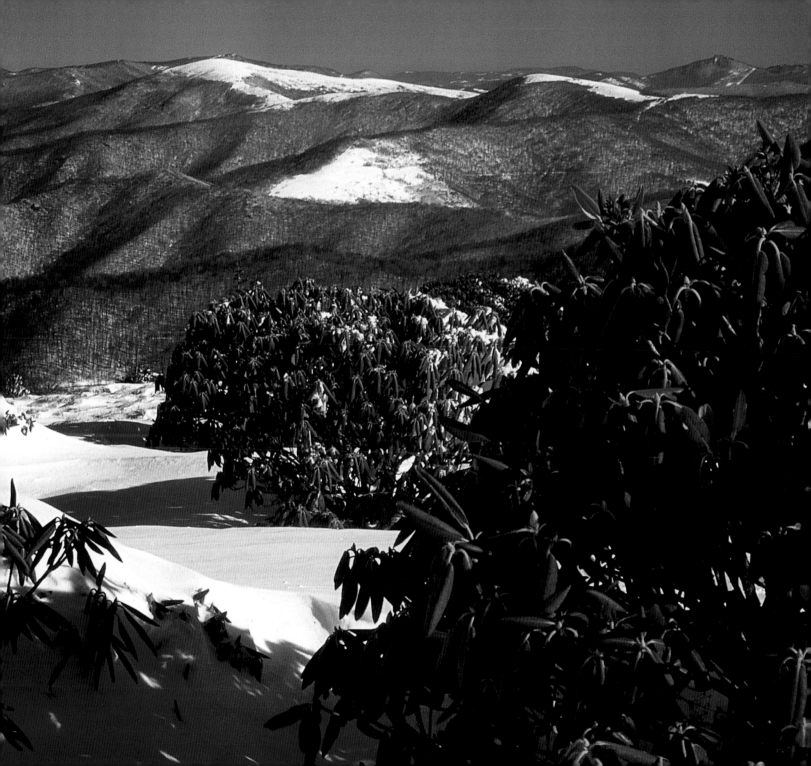

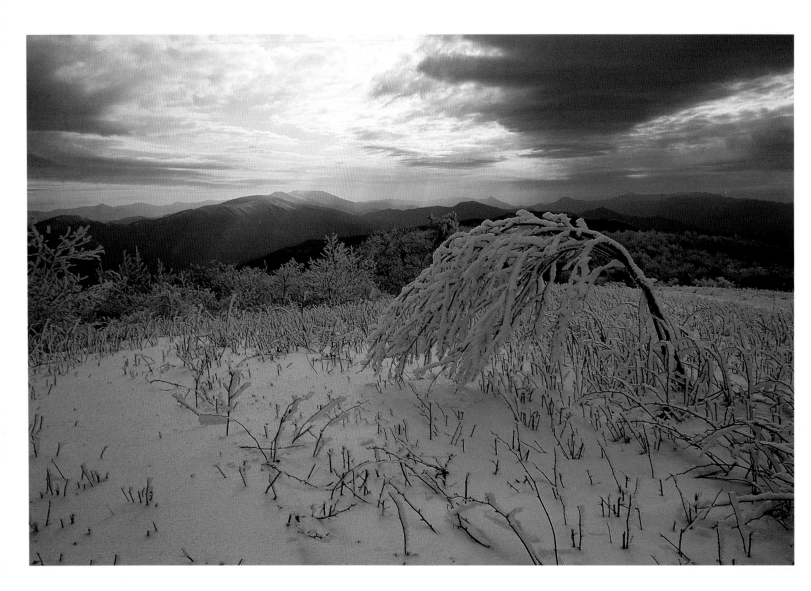

Winter along the Appalachian Trail, Unaka Mountain Wilderness, Tennessee

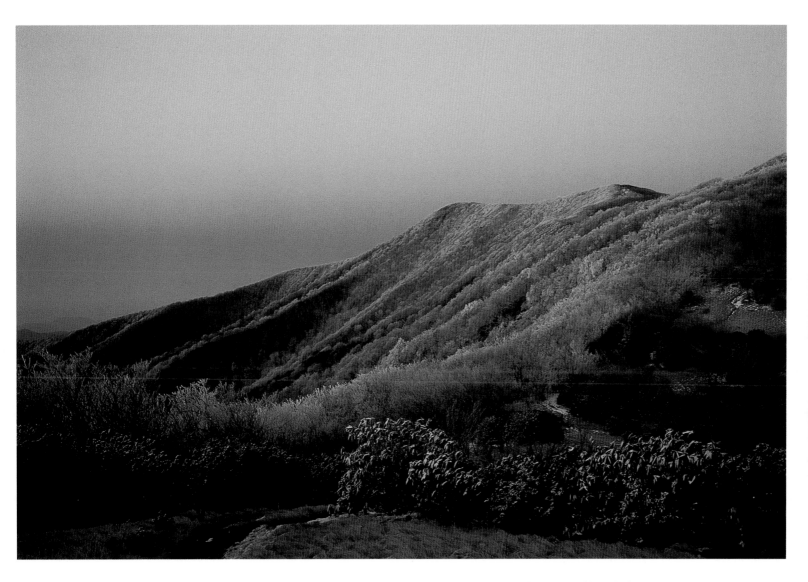

Winter frost on Thunderhead Mountain, Great Smoky Mountain National Park, Tennessee / North Carolina

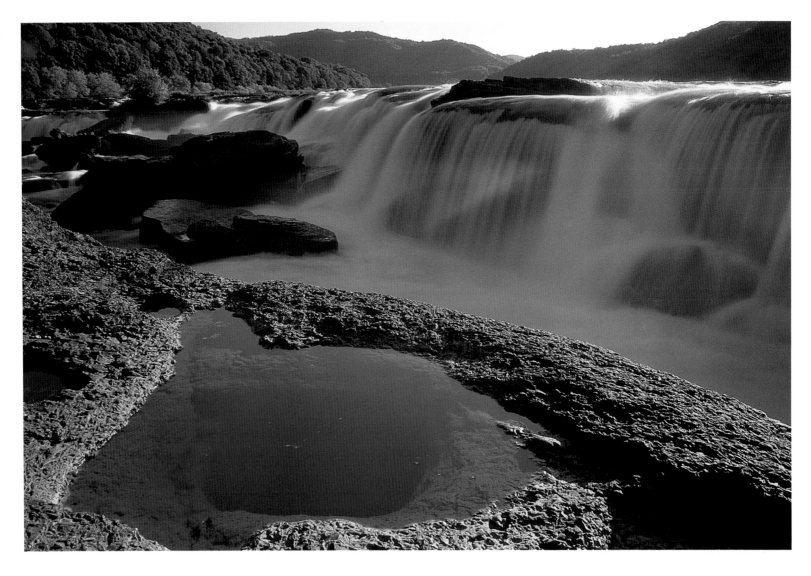

Waterfall and pool, New River Gorge National River, West Virginia

Spring showers feed the Linville Falls, Blue Ridge Parkway, North Carolina

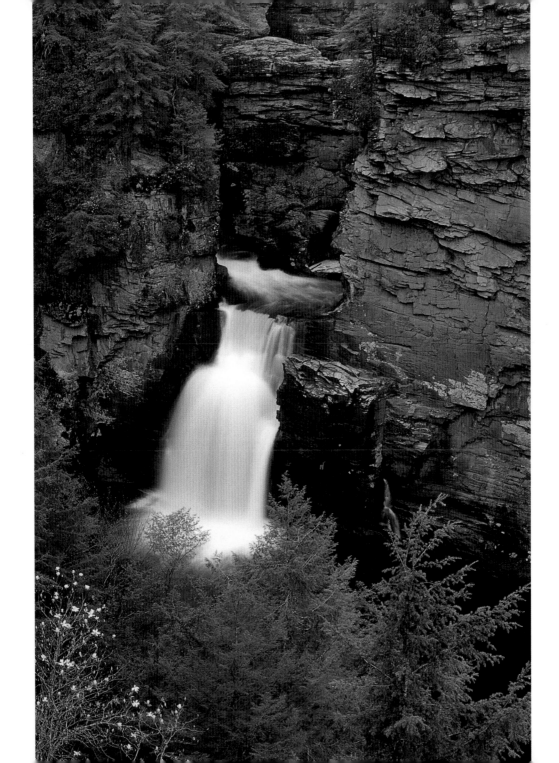

About The Photographer

Jerry Greer has been capturing images of our natural world since 1989. His images have appeared in numerous regional and national publications, including Backpacker, Blue Ridge Country, Appalachian Trailway News, and Mountain Bike magazine. "APPALACHIA – The Southern Highlands" is his first book. Jerry lives in Johnson City, Tennessee with his wife, Angela, and their two dogs, Shep and Garth.